Flowers *of* Youth

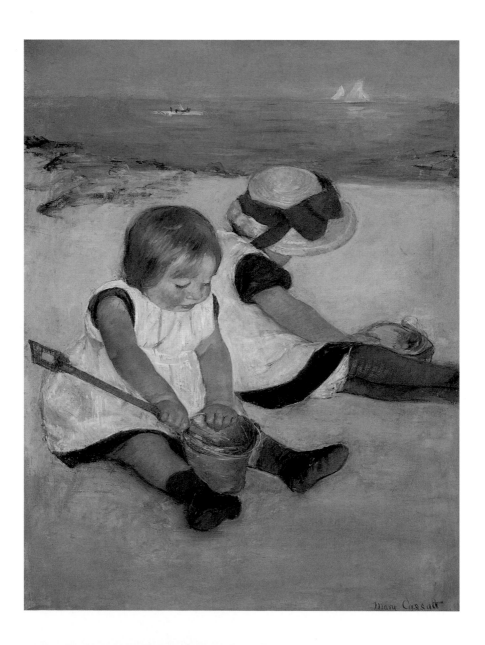

Flowers *of* Youth

Images of Children from the National Gallery of Art

A Bulfinch Press Book

Little, Brown and Company

Boston New York Toronto London

FIRST EDITION

Library of Congress Cataloging-in-Publication Data
National Gallery of Art (U.S.)
 Flowers of Youth : images of children from the National
 Gallery of Art / /National Gallery of Art.
 p. cm.
 Includes index.
 ISBN 0-8212-2321-6 (hardcover)
 1. Children in art—Catalogs. 2. Painting—Washington
 (D.C.) —Catalogs. 3. National Gallery of Art (U.S.)—Catalogs.
 4. Children—Poetry. I. Title.
 ND1460.C48N38 1996
 757' .5'074753—dc20 96-5906

Compiled and edited by Patricia J. Fidler

Bulfinch Press is an imprint and trademark of Little, Brown and
Company (Inc.)
Published simultaneously in Canada by Little, Brown & Company
(Canada) Limited

PRINTED IN SINGAPORE

Contents

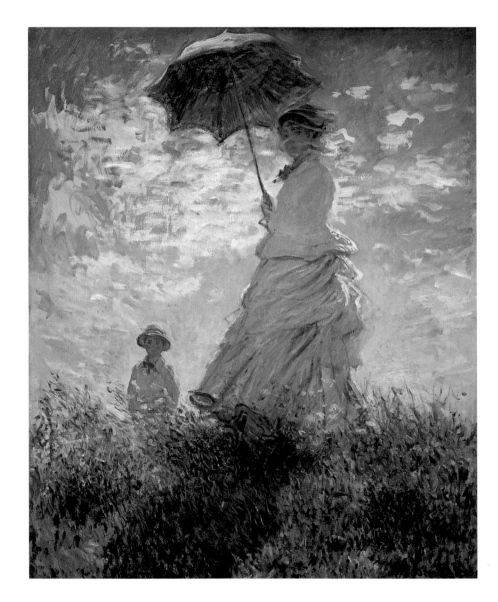

Claude Monet
Woman with a Parasol—Madame Monet and Her Son, 1875

I will be the gladdest thing
 Under the sun!
I will touch a hundred flowers
 And not pick one.

I will look at cliffs and clouds
 With quiet eyes,
Watch the wind bow down the grass,
 And the grass rise.

And when lights begin to show
 Up from the town,
I will mark which must be mine,
 And then start down!

EDNA ST. VINCENT MILLAY (1892–1950)

Afternoon on a Hill

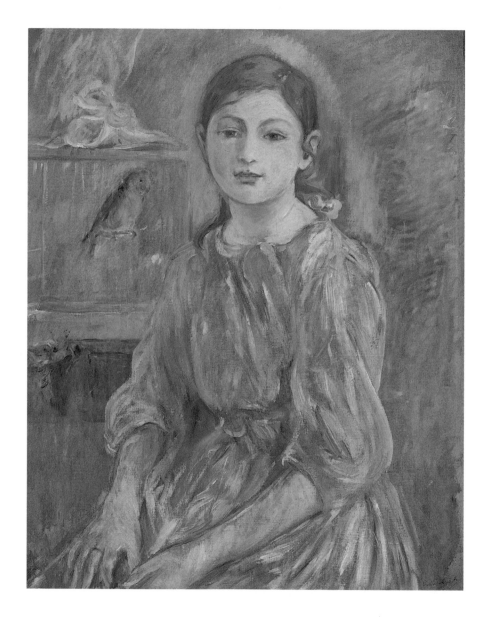

Berthe Morisot
The Artist's Daughter with a Parakeet, 1890

Pretty prating poll,
Answer to my call,
Thou art all in all
 My lovely bird;
Prithee give a kiss
To thine own dear Miss,
Thou can'st do no less
 Upon my word.

Perch upon my hand,
Take awhile thy stand,
Be at my command,
 Thy head recline;
I will stroke thy back,
Give thee nuts to crack,
Nothing shalt thou lack
 Of all that's mine.

Mimic now the cock,
Now the quacking duck,
Lisping Lettice mock,
 My wanton do;
Pleasant is thy voice,
Does my heart rejoice,
Never once annoys,
 I love thee so.

To thy perch away,
Chatter all the day,
While I work or play
 As I think fit;
Yet thy prittle-pattle
Is no more than rattle,
Without sense thy twattle,
 More noise than wit.

Well thou hast been taught,
Yet what hast thou got?
Tongue without a thought,
 Poor mimic fool!
Is it not absurd,
That a senseless bird,
Which knows not a word,
 My mind should rule?

JOHN MARCHANT (fl. 1751)

Little Miss and
Her Parrot

Hans Holbein the Younger
Edward VI as a Child, probably 1538

Go forth to life, oh! child of Earth.
Still mindful of thy heavenly birth;
Thou art not here for ease or sin,
But manhood's noble crown to win.

Though passion's fires are in thy soul,
Thy spirit can their flames control;
Though tempters strong beset thy way,
Thy spirit is more strong than they.

Go on from innocence of youth
To manly pureness, manly truth;
God's angels still are near to save,
And God himself doth help the brave.

Then forth to life, oh! child of Earth,
Be worthy of thy heavenly birth,
For noble service thou art here;
Thy brothers help, thy God revere!

SAMUEL LONGFELLOW (1819–92)

Go Forth to Life

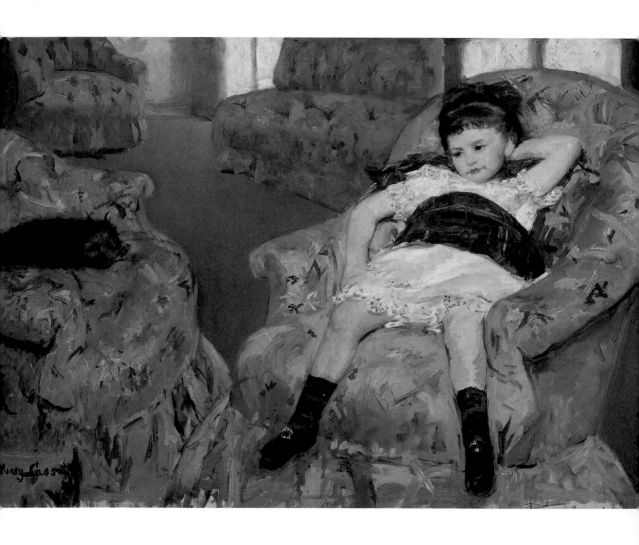

Mary Cassatt

Little Girl in a Blue Armchair, 1878

There was a little girl
　Who had a little curl
Right in the middle of her forehead.
　When she was good
　She was very, very good,
But when she was bad she was horrid.

HENRY WADSWORTH LONGFELLOW? (1807–82)

There Was a Little Girl

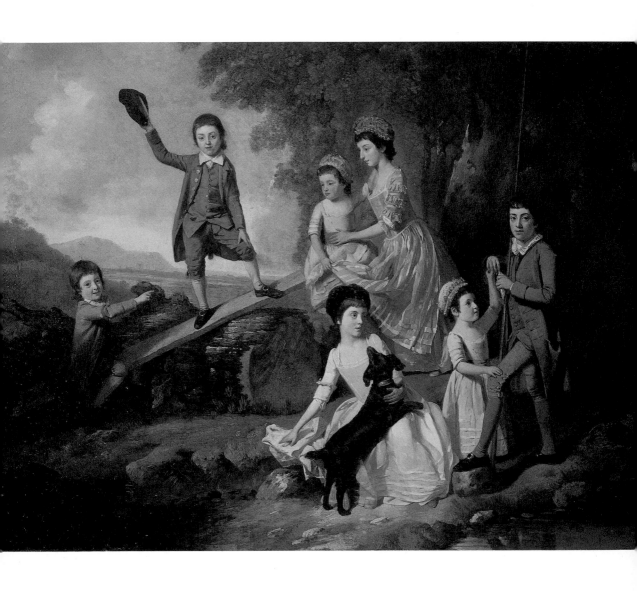

Johann Zoffany
The Lavie Children, c. 1770

Children, you are very little,
And your bones are very brittle;
If you would grow great and stately,
You must try to walk sedately.

You must still be bright and quiet,
And content with simple diet;
And remain, through all bewild'ring,
Innocent and honest children.

Happy hearts and happy faces,
Happy play in grassy places—
That was how, in ancient ages,
Children grew to kings and sages.

But the unkind and the unruly,
And the sort who eat unduly,
They must never hope for glory—
Theirs is quite a different story!

Cruel children, crying babies,
All grow up as geese and gabies,
Hated, as their age increases,
By their nephews and their nieces.

ROBERT LOUIS STEVENSON (1850–94)

Good and
Bad Children

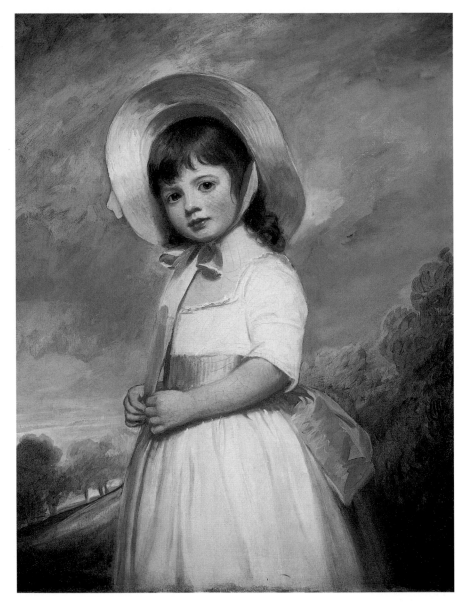

George Romney
Miss Juliana Willoughby, 1781–83

Fairest flower, all flowers excelling,
 Which in Eden's garden grew;
Flowers of Eve's embowered dwelling
 Are, my fair one, types of you.
Mark, my Polly, how the roses
 Emulate thy damask cheek;
How the bud its sweets discloses—
 Buds thy opening bloom bespeak.
Lilies are, by plain direction,
 Emblems of a double kind;
Emblems of thy fair complexion,
 Emblems of thy fairer mind.
But, dear girl, both flowers and beauty
 Blossom, fade, and die away;
Then pursue good sense and duty,
 Evergreens that ne'er decay.

Nathaniel Cotton (1705–88)

To a Child
Five Years Old

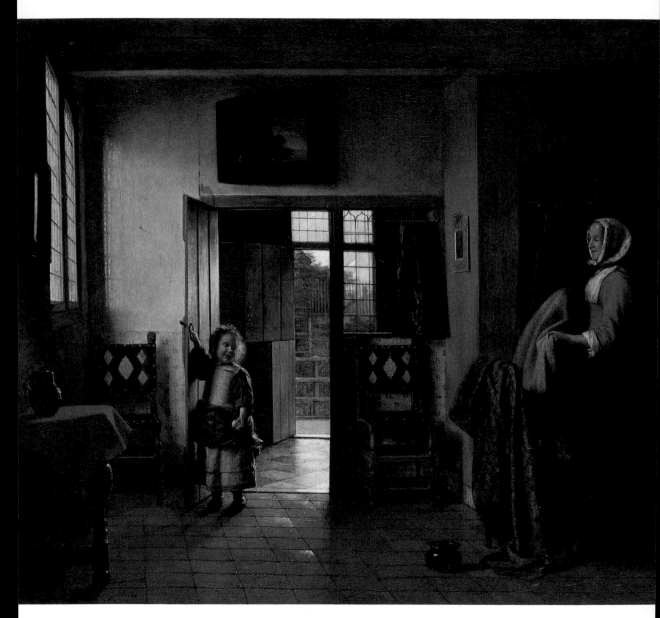

Pieter de Hooch
The Bedroom, 1658/60

Some one came knocking
 At my wee, small door;
Some one came knocking,
 I'm sure—sure—sure;
I listened, I opened,
 I looked to left and right,
But nought there was a-stirring
 In the still dark night;
Only the busy beetle
 Tap-tapping in the wall,
Only from the forest
 The screech-owl's call,
Only the cricket whistling
 While the dewdrops fall,
So I know not who came knocking,
 At all, at all, at all.

WALTER DE LA MARE (1873–1956)

Some One

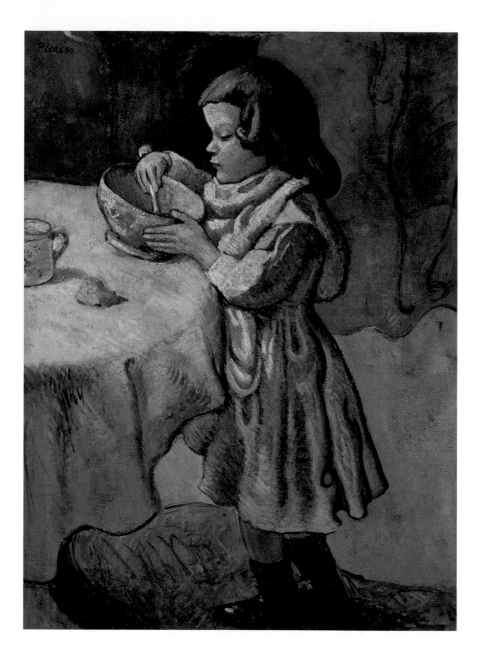

Pablo Picasso
Le Gourmet, 1901

A child should always say what's true
And speak when he is spoken to,
And behave mannerly at table;
At least as far as he is able.

<small>ROBERT LOUIS STEVENSON (1850–94)</small>

Whole Duty
of Children

22
23

Mary Cassatt
Mother and Child, c. 1905

Little drops of water,
 Little grains of sand,
Make the mighty ocean
 And the beauteous land.

And the little moments,
 Humble though they be,
Make the mighty ages
 Of eternity.

So our little errors
 Lead the soul away,
From the paths of virtue
 Into sin to stray.

Little deeds of kindness,
 Little words of love,
Make our earth an Eden,
 Like the heaven above.

JULIA A. CARNEY (1823–1908)

Little Things

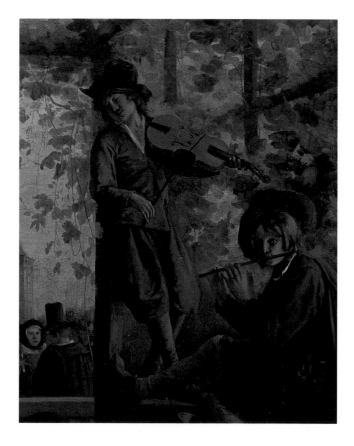

Jan Steen
The Dancing Couple (detail), 1663

O who will walk a mile with me
 Along life's merry way?
A comrade blithe and full of glee,
Who dares to laugh out loud and free
And let his frolic fancy play,
Like a happy child, through the flowers gay
That fill the field and fringe the way
 Where he walks a mile with me.

And who will walk a mile with me
 Along life's weary way?
A friend whose heart has eyes to see
The stars shine out o'er the darkening lea,
And the quiet rest at the end o' the day —
A friend who knows, and dares to say,
The brave, sweet words that cheer the way
 Where he walks a mile with me.

With such a comrade, such a friend,
I fain would walk till journey's end,
Through summer sunshine, winter rain,
And then? — Farewell, we shall meet again!

Henry van Dyke (1852 1933)

A Wayfaring Song

Auguste Renoir
A Girl with a Watering Can, 1876

Every child who has gardening tools,
Should learn by heart these gardening rules:

He who owns a gardening spade,
Should be able to dig the depth of its blade.

He who owns a gardening rake,
Should know what to leave and what to take.

He who owns a gardening hoe,
Must be sure how he means his strokes to go.

But he who owns a gardening fork,
May make it do all the other tools' work

Though to shift, or to pot, or annex what you can,
A trowel's the tool for child, woman, or man.

'Twas the bird that sits in the medlar-tree,
Who sang these gardening saws to me.

JULIANA HORATIA EWING (1841–85)

Garden Lore

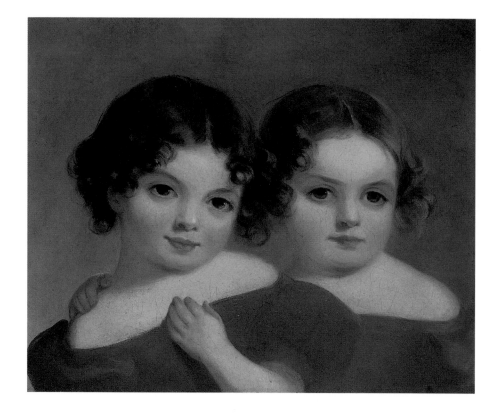

Thomas Sully
The Leland Sisters, c. 1830

Monday's child is fair of face,
Tuesday's child is full of grace,
Wednesday's child is full of woe,
Thursday's child has far to go,
Friday's child is loving and giving,
Saturday's child works hard for a living,
And the child that is born on the Sabbath day
Is bonny and blithe, and good and gay.

ANONYMOUS

Monday's Child
Is Fair of Face

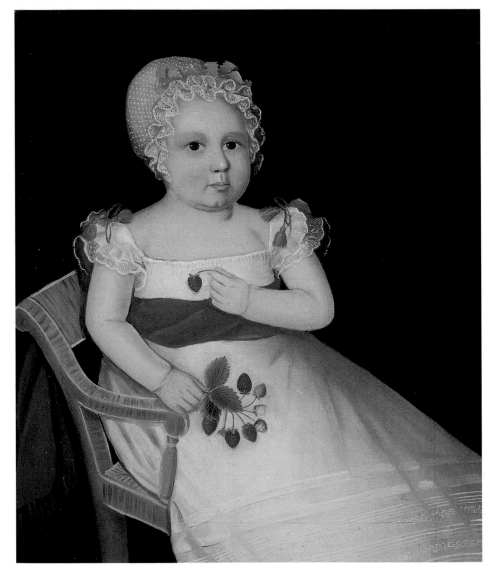

Ammi Phillips
The Strawberry Girl, c. 1830

My baby has no name yet;
like a new-born chick or a puppy,
my baby is not named yet.

What numberless texts I examined
at dawn and night and evening over again!
But not one character did I find
which is as lovely as the child.

Starry field of the sky,
or heap of pearls in the depth.
Where can the name be found, how can I?

My baby has no name yet;
like an unnamed bluebird or white flowers
from the farthest land for the first,
I have no name for this baby of ours.

KIM NAM-JO (1927–)

My Baby Has
No Name Yet

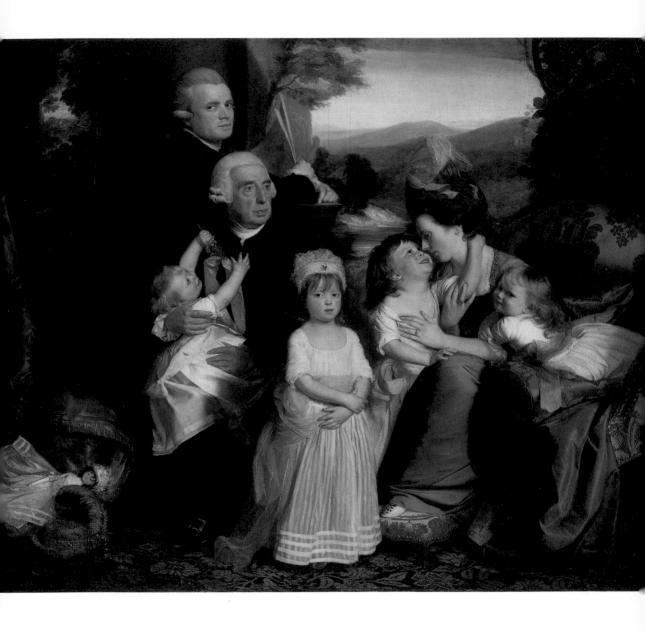

John Singleton Copley
The Copley Family, 1776/77

Between the dark and the daylight,
 When the night is beginning to lower,
Comes a pause in the day's occupations,
 That is known as the Children's Hour.

I hear in the chamber above me
 The patter of little feet,
The sound of a door that is opened,
 And voices soft and sweet.

From my study I see in the lamplight,
 Descending the broad hall stair,
Grave Alice, and laughing Allegra,
 And Edith with golden hair.

A whisper, and then a silence:
 Yet I know by their merry eyes
They are plotting and planning together
 To take me by surprise.

A sudden rush from the stairway,
 A sudden raid from the hall!
By three doors left unguarded
 They enter my castle wall!

They climb up into my turret
 O'er the arms and back of my chair;
If I try to escape, they surround me;
 They seem to be everywhere.

They almost devour me with kisses,
 Their arms about me entwine,
Till I think of the Bishop of Bingen
 In his Mouse Tower on the Rhine!

Do you think, O blue-eyed banditti,
 Because you have scaled the wall,
Such an old mustache as I am
 Is not a match for you all!

I have you fast in my fortress,
 And will not let you depart,
But put you down into the dungeon
 In the round-tower of my heart.

And there will I keep you forever,
 Yes, forever and a day,
Till the walls shall crumble to ruin,
 And molder in dust away!

HENRY WADSWORTH LONGFELLOW (1807–82)

The Children's Hour

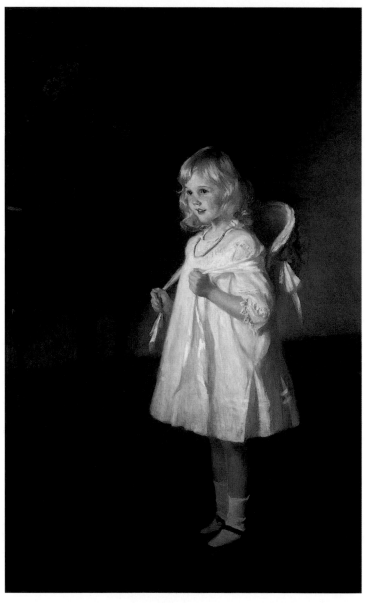

Lydia Field Emmet
Olivia, 1911

Single-eyed to child and sunbeam,
In her little grass-green gown,
Prim and sweet and fair as ever,
Blue-eyed Mary's come to town.

Yes, you may, child, go to see her,
You can stay and play an hour;
But be sweet and good and gentle;
Blue-eyed Mary is a flower.

MARY E. WILKINS FREEMAN (1852–1930)

Blue-eyed Mary

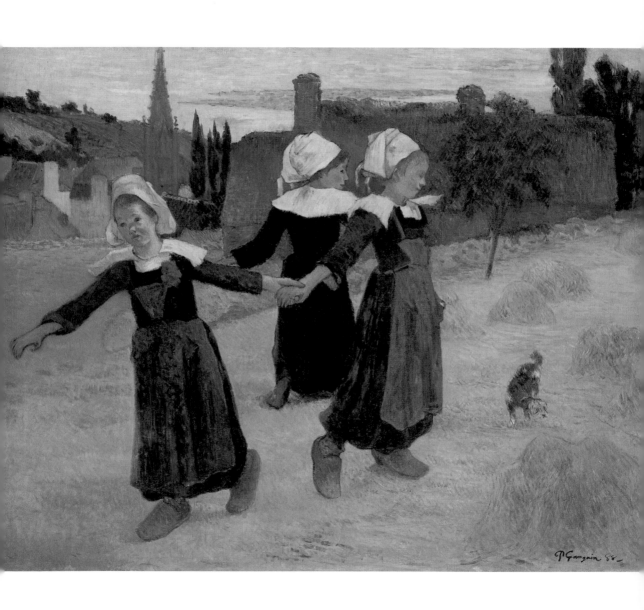

Paul Gauguin
Breton Girls Dancing, Pont-Aven, 1888

When the green woods laugh with the voice of joy,
And the dimpling stream runs laughing by;
When the air does laugh with our merry wit,
And the green hill laughs with the noise of it;

When the meadows laugh with lively green,
And the grasshopper laughs in the merry scene;
When Mary and Susan and Emily
With their sweet round mouths sing "Ha, ha, he!"

When the painted birds laugh in the shade,
When our table with cherries and nuts is spread:
Come live, and be merry, and join with me
To sing the sweet chorus of "Ha, ha, he!"

WILLIAM BLAKE (1757–1827)

Laughing Song

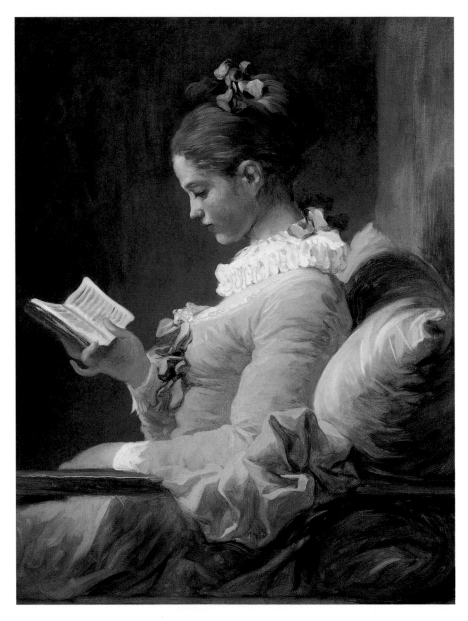

Jean-Honoré Fragonard
A Young Girl Reading, c. 1776

Dear child, these words which briefly I declare,
Let them not hang like jewels in thine ear;
But in the secret closet of thine heart,
Lock them up safe, that they may ne'er depart.

Give first to God the flower of thy youth;
Take Scripture for thy guide, that word of truth;
Adorn thy soul with grace; prize wisdom more
Than all the pearls upon the Indian shore.
Think not to live still free from grief and sorrow:
That man who laughs today, may weep tomorrow.
Nor dream of joys unmixèd, here below:
No roses here, but what on thorns do grow.

Let not thy wingèd days be spent in vain;
When gone, no gold will call them back again.
Strive to subdue thy sin, when first beginning;
Custom (when once confirmed) is strangely winning.
Be much in prayer: it is the begging-trade
By which true Christians are the richest made.

Be loving, patient, courteous, and kind:
So doing, thou shalt praise and honour find
Here upon earth; and when all-conquering death
Thy body shall dissolve, and stop thy breath,
Upon the golden wings of faith and love
Thy soul shall fly to paradise above.

The Maiden's
Best Adorning

ANONYMOUS (1687)

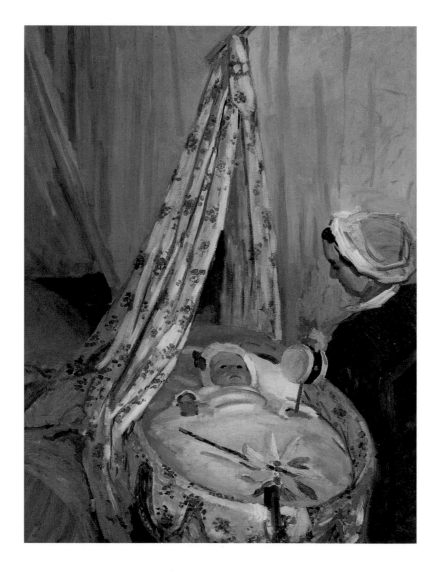

Claude Monet
The Cradle—Camille with the Artist's Son Jean, 1867

Golden slumbers kiss your eyes,
Smiles awake you when you rise.
Sleep, pretty wantons, do not cry,
And I will sing a lullaby:
Rock them, rock them, lullaby.

Care is heavy, therefore sleep you;
You are care, and care must keep you.
Sleep, pretty wantons, do not cry,
And I will sing a lullaby:
Rock them, rock them, lullaby.

THOMAS DEKKER (1572?–1632)

A Cradle Song

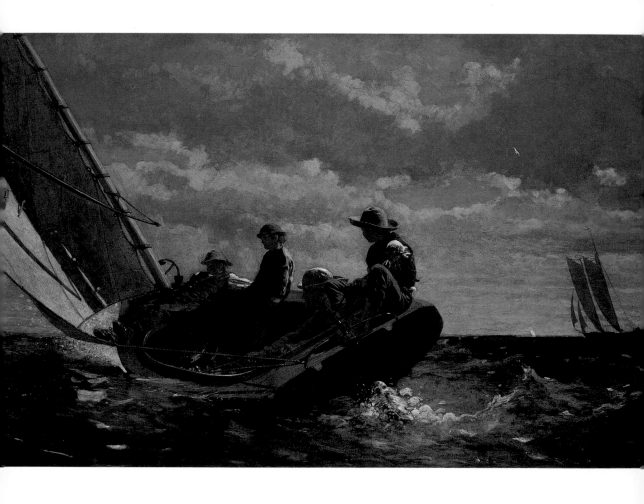

Winslow Homer
Breezing Up (A Fair Wind), 1873–76

A wet sheet and a flowing sea,
 A wind that follows fast,
And fills the white and rustling sail,
 And bends the gallant mast:
And bends the gallant mast, my boys,
 While like the eagle free
Away the good ship flies and leaves
 Old England on the lee.

Oh, for a soft and gentle wind!
 I heard a fair one cry:
But give to me the snoring breeze,
 And white waves heaving high;
And white waves heaving high, my boys,
 The good ship tight and free —
The world of waters is our home,
 And merry men are we.

There's a tempest in yon hornèd moon,
 And lightning in yon cloud:
But, hark! the music, mariners!
 The wind is piping loud;
The wind is piping loud, my boys,
 The lightning flashing free —
While the hollow oak our palace is,
 Our heritage the sea.

ALLAN CUNNINGHAM (1784–1842)

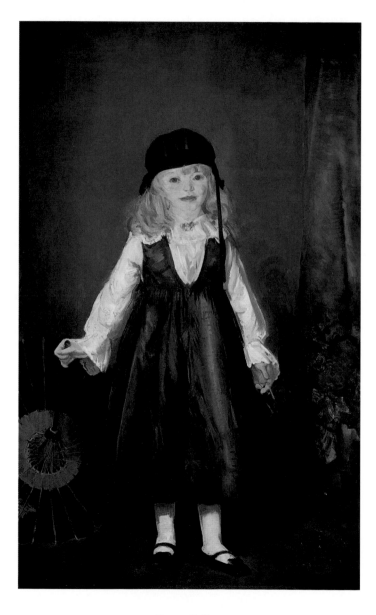

George Bellows
Anne with a Japanese Parasol, 1917

Little girl, be careful what you say
when you make talk with words, words—
for words are made of syllables
and syllables, child, are made of air—
and air is so thin—air is the breath of God—
air is finer than fire or mist,
finer than water or moonlight,
finer than spiderwebs in the moon,
finer than water-flowers in the morning:
 and words are strong, too,
 stronger than rocks or steel
stronger than potatoes, corn, fish, cattle,
and soft, too, soft as little pigeon-eggs,
soft as the music of humming bird wings.
 So, little girl, when you speak greetings,
when you tell jokes, make wishes or prayers,
 be careful, be careless, be careful,
 be what you wish to be.

CARL SANDBURG (1878–1967)

Little Girl,
Be Careful What
You Say

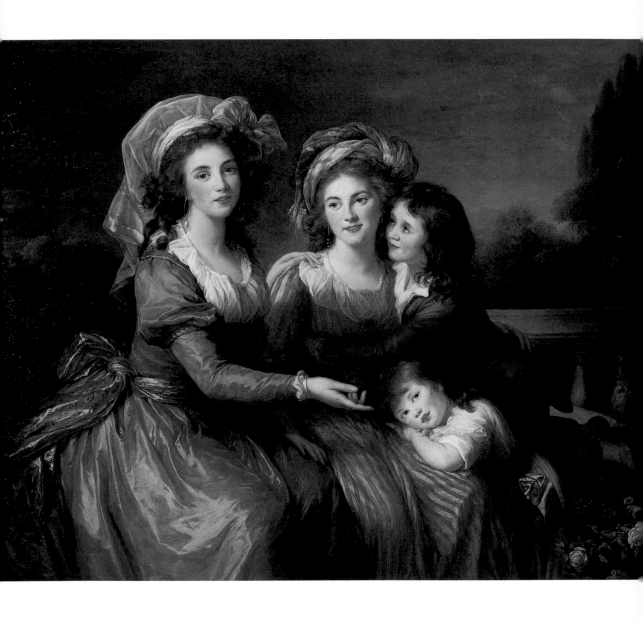

Elisabeth Vigée-Lebrun
The Marquise de Pezé and the Marquise de Rouget with Her Two Children, 1787

O Mother-My-Love, if you'll give me your hand,
 And go where I ask you to wander,
I will lead you away to a beautiful land —
 The Dreamland that's waiting out yonder.
We'll walk in a sweet-posie garden out there
 Where moonlight and starlight are streaming
And the flowers and the birds are filling the air
 With the fragrance and music of dreaming.

There'll be no little tired-out boy to undress,
 No questions or cares to perplex you;
There'll be no little bruises or bumps to caress,
 Nor patching of stockings to vex you.
For I'll rock you away on a silver-dew stream,
 And sing you asleep when you're weary,
And no one shall know of our beautiful dream
 But you and your own little dearie.

And when I am tired I'll nestle my head
 In the bosom that's soothed me so often,
And the wide-awake stars shall sing in my stead
 A song which our dreaming shall soften.
So, Mother-My-Love, let me take your dear hand,
 And away through the starlight we'll wander —
Away through the mist to the beautiful land —
 The Dreamland that's waiting out yonder!

EUGENE FIELD (1850–95)

Child and Mother

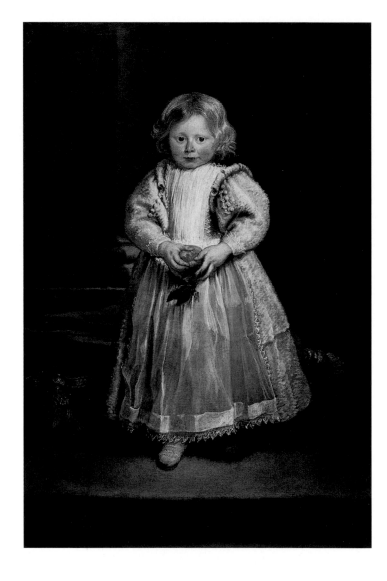

Sir Anthony van Dyck
Clelia Cattaneo, Daughter of Marchesa Elena Grimaldi, 1623

Violets, daffodils,
 roses and thorn
were all in the garden
 before you were born.

Daffodils, violets,
 red and white roses
your grandchildren's children
 will hold to their noses.

ELIZABETH COATSWORTH (1893–1986)

Nosegay

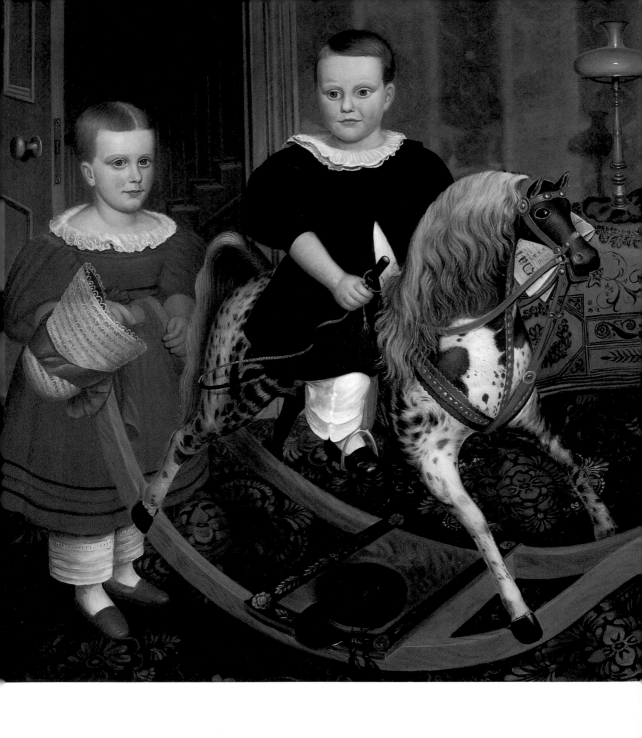

The little toy dog is covered with dust,
 But sturdy and stanch he stands;
And the little toy soldier is red with rust,
 And his musket molds in his hands.
Time was when the little toy dog was new
 And the soldier was passing fair;
And that was the time when our Little Boy Blue
 Kissed them and put them there.

"Now, don't you go till I come," he said,
 "And don't you make any noise!"
So, toddling off to his trundle-bed,
 He dreamed of the pretty toys;
And as he was dreaming, an angel song
 Awakened our Little Boy Blue—
Oh! the years are many, the years are long,
 But the little toy friends are true!

Little Boy Blue

Aye, faithful to Little Boy Blue they stand,
 Each in the same old place—
Awaiting the touch of a little hand,
 And the smile of a little face;
And they wonder, as waiting these long years through
 In the dust of that little chair,
What has become of our Little Boy Blue,
 Since he kissed them and put them there.

EUGENE FIELD (1850–95)

American 19th Century
The Hobby Horse, c. 1840

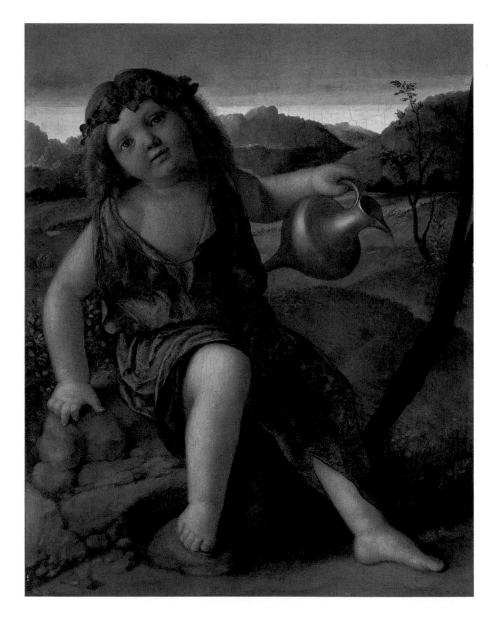

Giovanni Bellini
The Infant Bacchus, probably 1505–10

For thee, little boy, will the earth pour forth gifts
All untilled, give thee gifts
First the wandering ivy and foxglove
Then colocasia and the laughing acanthus
Uncalled the goats will come home with their milk
No longer need the herds fear the lion
Thy cradle itself will bloom with sweet flowers

The serpent will die
The poison plant will wither
Assyrian herbs will spring up everywhere

And when thou art old enough to read of heroes
And of thy father's great deeds
Old enough to understand the meaning of courage
Then will the plain grow yellow with ripe grain
Grapes will grow on brambles
Hard old oaks drip honey.

VIRGIL, from *Eclogue 4* (70–19 B.C.)

For Thee, Little Boy

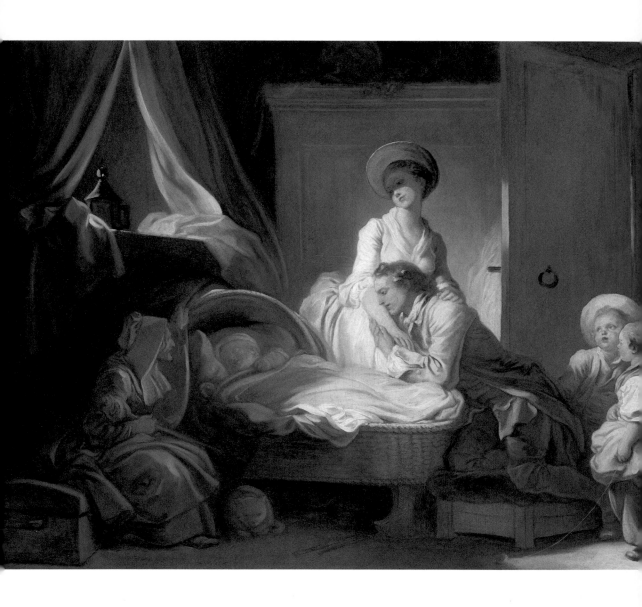

Jean-Honoré Fragonard
The Visit to the Nursery, before 1784

"Hope" is the thing with feathers
That perches in the soul,
And sings the tune without the words,
And never stops at all,

And sweetest in the gale is heard;
And sore must be the storm
That could abash the little bird
That kept so many warm.

I've heard it in the chillest land,
And on the strangest sea;
Yet, never, in extremity,
It asked a crumb of me.

Emily Dickinson (1830–86)

"Hope" Is the Thing
with Feathers

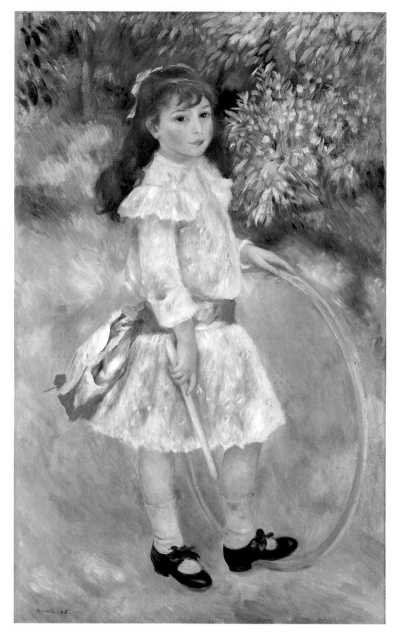

Auguste Renoir
Girl with a Hoop, 1885

Dainty little maiden, whither would you wander?
 Whither from this pretty home, the home where mother dwells?
"Far and far away," said the dainty little maiden,
"All among the gardens, auriculas, anemones,
 Roses and lilies and Canterbury-bells."

Dainty little maiden, whither would you wander?
 Whither from this pretty house, this city house of ours?
"Far and far away," said the dainty little maiden,
"All among the meadows, the clover and the clematis,
 Daisies and kingcups and honeysuckle-flowers."

ALFRED, LORD TENNYSON (1809–92)

The City Child

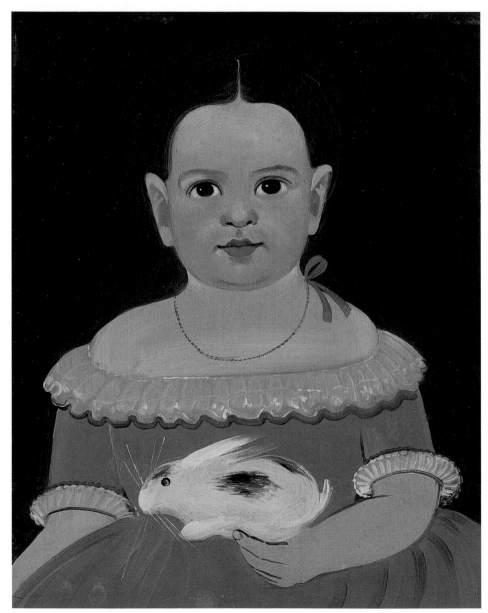

Sturtevant J. Hamblin
Little Girl with Pet Rabbit, c. 1845

If no one ever marries me,
 And I don't see why they should,
For nurse says I'm not pretty,
 And I'm seldom very good—

If no one ever marries me,
 I shan't mind very much,
I shall buy a squirrel in a cage,
 And a little rabbit hutch;

I shall have a cottage near a wood,
 And a pony all my own,
And a little lamb, quite clean and tame,
 That I can take to town.

And when I'm getting really old—
 At twenty-eight or nine—
I shall find a little orphan girl
 And bring her up as mine.

SIR LAWRENCE ALMA-TADEMA (1836–1912)

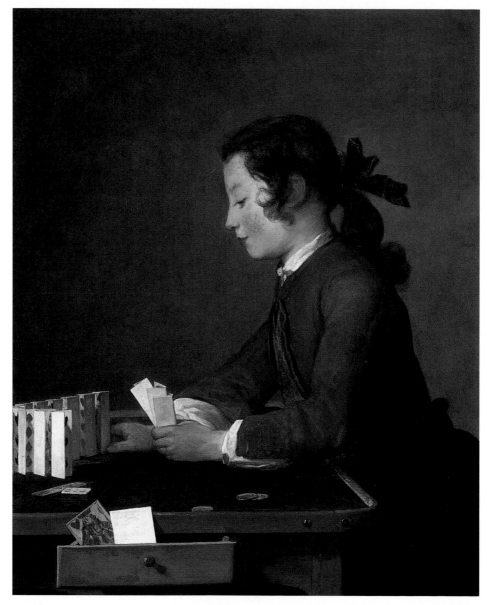

Jean Siméon Chardin

The House of Cards, c. 1735

The boy that is good,
Does learn his book well;
And if he can't read,
Will strive for to spell.

His school he does love,
And when he is there,
For play and for toys,
No time can he spare.

His mind is full bent,
On what he is taught;
He sits in the school,
As one full of thought.

Though not as a mope,
Who quakes out of fear
The whip or the rod
Should fall on his rear.

But like a good lad
Who aims to be wise,
He thinks on his book,
And not on his toys.

His mien will be grave,
Yet, if you would know,
He plays with an air,
When a dunce dare not so.

His aim is to learn,
His task is his play;
And when he has learned,
He smiles and looks gay.

HENRY DIXON (1675–1760)

The Description of
a Good Boy

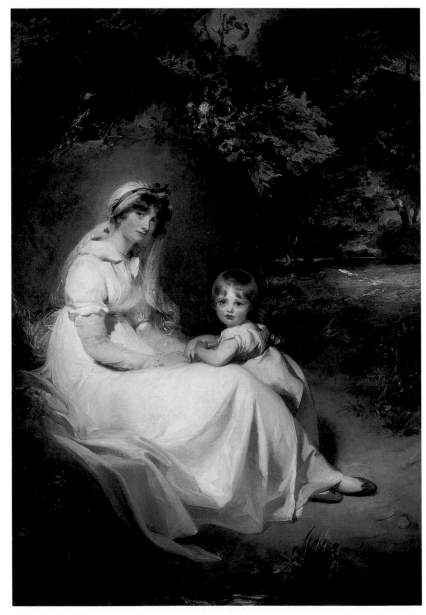

62
63

Sir Thomas Lawrence
Lady Mary Templetown and Her Eldest Son, 1802

Where did you come from, baby dear?
Out of the everywhere into here.

Where did you get your eyes so blue?
Out of the sky as I came through.

What makes the light in them sparkle and spin?
Some of the starry spikes left in.

Where did you get that little tear?
I found it waiting when I got here.

Baby

What makes your forehead so smooth and high?
A soft hand stroked it as I went by.

GEORGE MACDONALD (1824–1905)

James Jacques Joseph Tissot
Hide and Seek (detail), c. 1877

I'm hiding, I'm hiding,
And no one knows where;
For all they can see is my
Toes and my hair.

And I just heard my father
Say to my mother—
"But, darling, he must be
Somewhere or other;

"Have you looked in the ink well?"
And Mother said, "Where?"
"In the INK WELL," said Father. But
I was not there.

Then "Wait!" cried my mother—
"I think that I see
Him under the carpet." But
It was not me.

"Inside the mirror's
A pretty good place,"
Said Father and looked, but saw
Only his face.

"We've hunted," sighed Mother,
"As hard as we could
And I AM so afraid that we've
Lost him for good."

Then I laughed out aloud
And I wiggled my toes
And Father said—"Look, dear,
I wonder if those

Toes could be Benny's.
There are ten of them. See?"
And they WERE so surprised to find
Out it was me!

DOROTHY ALDIS (1896–1966)

Hiding

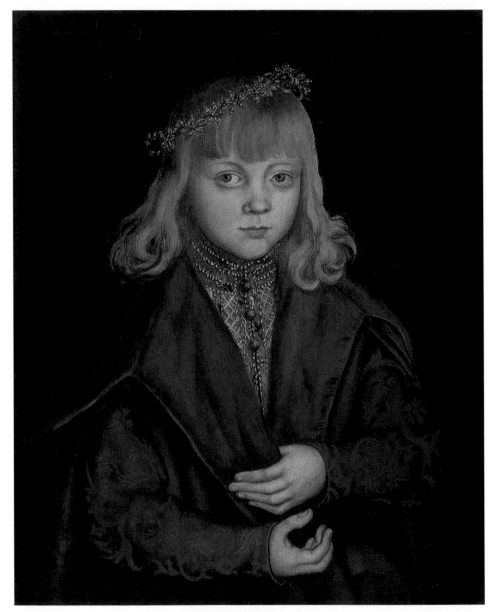

Lucas Cranach the Elder
A Prince of Saxony, c. 1517

It is to a goodly child well fitting
 To use disports of mirth and pleasance,
To harp, or lute, or lustily to sing,
 Or in the press right mannerly to dance.
 When men see a child of such governance
 They say, "Glad may this child's friends be
 To have a child so mannerly as he."

ANONYMOUS (*c.* 1478)

A Goodly Child

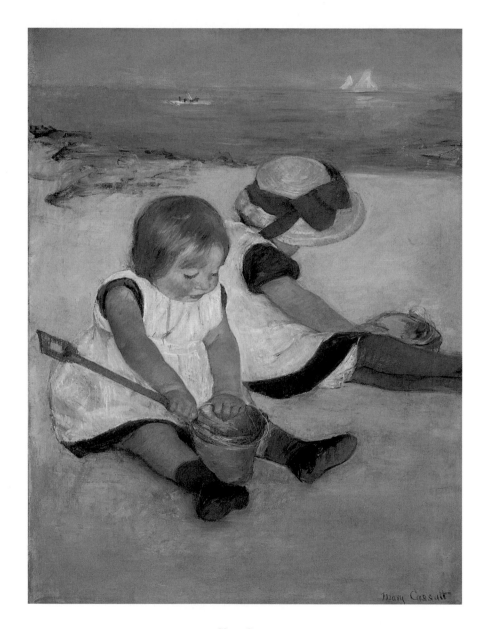

Mary Cassatt

Children Playing on the Beach, 1884

When I was down beside the sea
A wooden spade they gave to me
 To dig the sandy shore.
My holes were empty like a cup,
In every hole the sea came up,
 Till it could come no more.

ROBERT LOUIS STEVENSON (1850–94)

At the Seaside

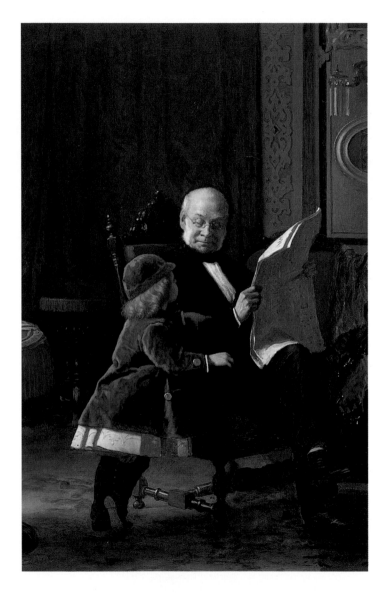

Eastman Johnson
The Brown Family (detail), 1869

We put more coal on the big red fire,
And while we are waiting for dinner to cook,
Our father comes and tells us about
A story that he has read in a book.

And Charles and Will and Dick and I
And all of us but Clarence are there.
And some of us sit on Father's legs,
But one has to sit on the little red chair.

And when we are sitting very still,
He sings us a song or tells a piece;
He sings Dan Tucker Went to Town,
Or he tells us about the golden fleece.

Father's Story

He tells us about the golden wool,
And some of it is about a boy
Named Jason, and about a ship,
And some is about a town called Troy.

And while he is telling or singing it through,
I stand by his arm, for that is my place.
And I push my fingers into his skin
To make little dents in his big round face.

ELIZABETH MADOX ROBERTS (1886–1941)

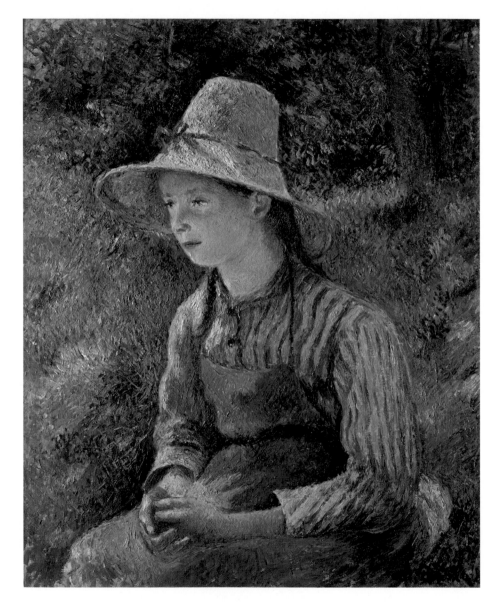

Camille Pissarro
Peasant Girl with a Straw Hat, 1881

Glad that I live am I;
That the sky is blue;
Glad for the country lanes,
And the fall of dew.

After the sun the rain;
After the rain the sun;
This is the way of life,
Till the work be done.

All that we need to do,
Be we low or high,
Is to see that we grow
Nearer the sky.

LIZETTE WOODWORTH REESE (1856–1935)

A Little Song
of Life

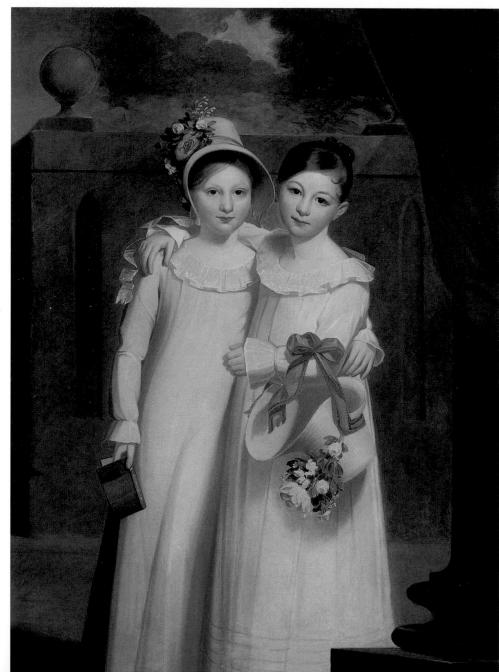

January brings the snow,
Makes our feet and fingers glow.

February brings the rain,
Thaws the frozen lake again.

March brings breezes, loud and shrill,
To stir the dancing daffodil.

April brings the primrose sweet,
Scatters daisies at our feet.

May brings flocks of pretty lambs
Skipping by their fleecy dams.

June brings tulips, lilies, roses,
Fills the children's hands with posies.

Hot July brings cooling showers,
Apricots, and gillyflowers.

August brings the sheaves of corn,
Then the harvest home is borne.

Warm September brings the fruit;
Sportsmen then begin to shoot.

Fresh October brings the pheasant;
Then to gather nuts is pleasant.

Dull November brings the blast;
Then the leaves are whirling fast.

Chill December brings the sleet,
Blazing fire, and Christmas treat.

SARA COLERIDGE (1802–52)

The Garden Year

Jacob Eichholtz
The Ragan Sisters, 1818

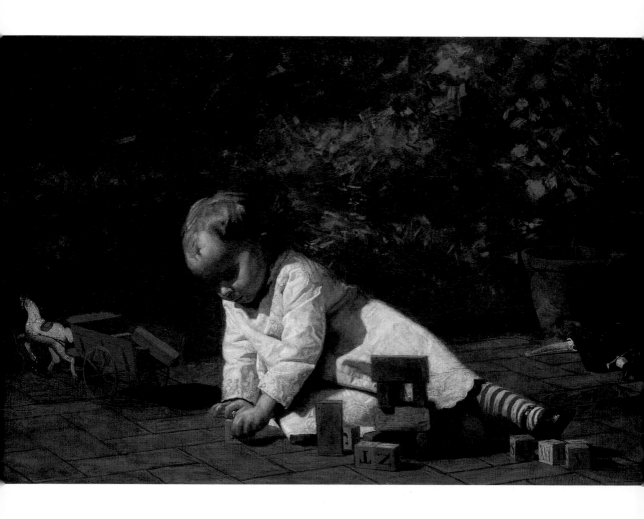

Thomas Eakins
Baby at Play, 1876

What are you able to build with your blocks?
Castles and palaces, temples and docks.
Rain may keep raining, and others go roam,
But I can be happy and building at home.

Let the sofa be mountains, the carpet be sea,
There I'll establish a city for me:
A kirk and a mill and a palace beside,
And a harbor as well where my vessels may ride.

Great is the palace with pillar and wall,
A sort of a tower on the top of it all,
And steps coming down in an orderly way,
To where my toy vessels lie safe in the bay.

Block City

This one is sailing and that one is moored:
Hark to the song of the sailors on board!
And see on the steps of my palace, the kings
Coming and going with presents and things!

ROBERT LOUIS STEVENSON (1850–94)

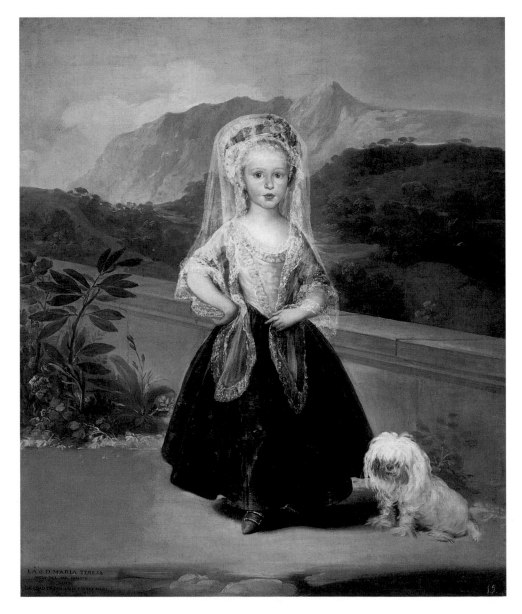

Francisco de Goya

María Teresa de Borbón y Vallabriga, later Condesa de Chinchón, 1783

Would'st be happy, little child,
Be thou innocent and mild:
Like the patient lamb and dove,
Full of meekness, full of love;
Modestly thy looks compose,
Sweet and blushing like the rose.

When in gardens thou dost play,
In the pleasant flowery May,
And art driven by sudden showers
From the fresh and fragrant flowers,
Think how short that pleasure is
Which the world esteemeth bliss.

When the fruits are sour and green,
Come not near them, be not seen
Touching, tasting, till the sun
His sweet ripening work hath done;
Think how harsh thy nature is
Till heaven ripen thee for bliss.

Or lest thou should'st drop away,
Like the leaf that fell today,
Still be ready to depart,
Love thy God with all thy heart;
Then thou wilt ascend on high,
From time to eternity.

Paradise is sweeter there,
Than the flowers and roses here;
Here's a glimpse, and then away,
There 'twill be forever day;
Where thou ever in heaven's spring
Shalt with saints and angels sing.

ANONYMOUS (1708)

To Theodora

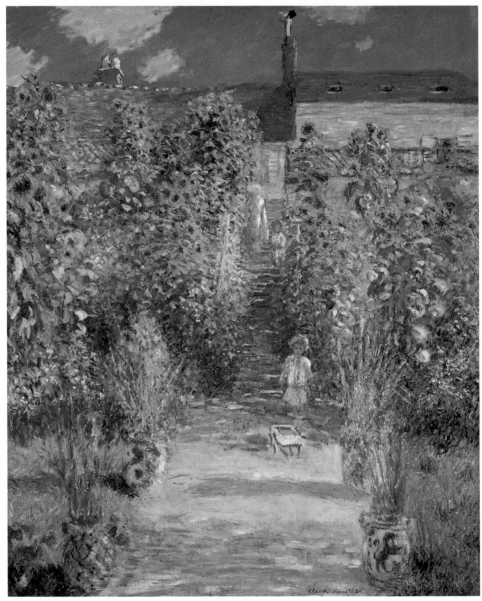

Claude Monet

The Artist's Garden at Vétheuil, 1880

If *you* go down to the garden path,
 All that you will see
Are daffodils and gilly-flowers,
 Beneath the lilac tree;
And a clump of double daisies, and a red anemone.

If *you* go down the garden path,
 All that you will hear
Is a blackbird in the hawthorne bush,
 Piping loud and clear;
And green leaves rustling gently, and a wild bee humming near.

If *I* go down the garden path,
 Softly, all alone,
Then I shall see a fairy peep
 From every bud half-blown;
While every blossom sings a song to music of its own.

If *I* go down the garden path,
 When the stars are lit,
I shall join the fairy ring
 And merrily dance in it;
For all the fairies know me, and they aren't afraid a bit!

CHARLOTTE DRUITT COLE

The Garden Path

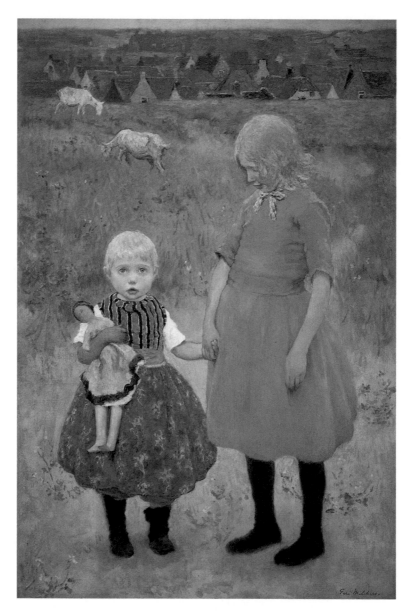

Gari Melchers
The Sisters, 1884/1900

What is pink? A rose is pink
By the fountain's brink.
What is red? A poppy's red
In its barley bed.
What is blue? The sky is blue
Where the clouds float thro'.
What is white? A swan is white
Sailing in the light.
What is yellow? Pears are yellow,
Rich and ripe and mellow.
What is green? The grass is green,
With small flowers between.
What is violet? Clouds are violet
In the summer twilight.
What is orange? Why, an orange,
Just an orange!

CHRISTINA ROSSETTI (1830–94)

What Is Pink?

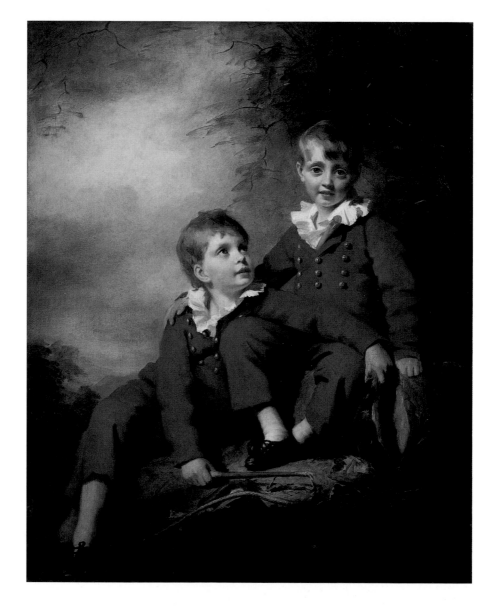

Sir Henry Raeburn
The Binning Children, probably c. 1811

Some boys (their minds denying virtue room),
The time do love in trifles to consume;
Others their fellows trouble, making sport
With hands or feet, or in some other sort;
And those there are that boasting of their stocks,
Disparage others with unsavoury mocks.
Such evil patterns do not thou regard,
Lest that thy deeds at length have just reward.
Nor buy, nor sell, nor changing give or take,
By others' loss do thou no profit make.
Let money go, which many hath defiled —
Nothing but what is chaste becomes a child.

JOHN PENKETHMAN (fl. 1630)

Some Boys

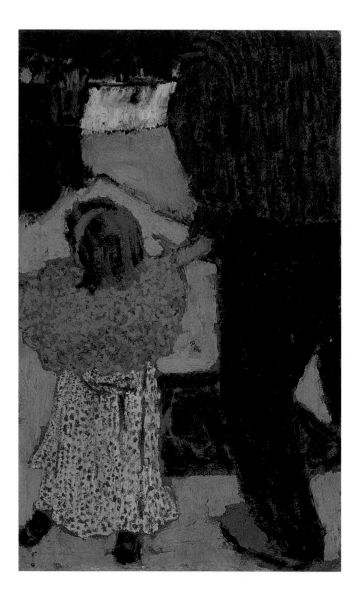

Edouard Vuillard
Child Wearing a Red Scarf, c. 1891

Two roads diverged in a yellow wood,
And sorry I could not travel both
And be one traveler, long I stood
And looked down one as far as I could
To where it bent in the undergrowth;

Then took the other, as just as fair,
And having perhaps the better claim,
Because it was grassy and wanted wear;
Though as for that, the passing there
Had worn them really about the same,

And both that morning equally lay
In leaves no step had trodden black.
Oh, I kept the first for another day!
Yet knowing how way leads on to way,
I doubted if I should ever come back.

I shall be telling this with a sigh
Somewhere ages and ages hence:
Two roads diverged in a wood, and I —
I took the one less traveled by,
And that has made all the difference.

ROBERT FROST (1874–1963)

The Road Not Taken

All paintings reproduced in this book are in the collections of the National Gallery of Art, Washington, D.C.

Index of Artists and Paintings

LUCAS CRANACH THE ELDER
German, 1472–1553
A Prince of Saxony, c. 1517 66
Oil on panel, 43.7 x 34.4 cm (17 1/4 x 13 1/2 in.)
Ralph and Mary Booth Collection
1947.6.1

SIR ANTHONY VAN DYCK
Flemish, 1599–1641
Clelia Cattaneo, Daughter of Marchesa Elena Grimaldi, 1623 48
Oil on canvas, 122.2 x 84.1 cm (48 1/8 x 33 1/8 in.)
Widener Collection
1942.9.94

THOMAS EAKINS
American, 1844–1916
Baby at Play, 1876 76
Oil on canvas, 81.9 x 122.8 cm (32 1/4 x 48 3/8 in.)
John Hay Whitney Collection
1982.76.5

JACOB EICHHOLTZ
American, 1776–1842
The Ragan Sisters, 1818 74
Oil on canvas, 151.2 x 108 cm (59 1/2 x 42 1/2 in.)
Gift of Mrs. Cooper R. Drewry
1959.6.1

LYDIA FIELD EMMET
American, 1866–1952
Olivia, 1911 34
Oil on canvas, 162.6 x 102.9 cm (64 x 40 1/2 in.)
Gift of Olivia Stokes Hatch
1983.96.1

JEAN-HONORÉ FRAGONARD
French, 1732–1806
The Visit to the Nursery, before 1784 54
Oil on canvas, 73 x 92.1 cm (28 3/4 x 36 1/4 in.)
Samuel H. Kress Collection
1946.7.7

A Young Girl Reading, c. 1776 38
Oil on canvas, 81.1 x 64.8 cm (32 x 25 1/2in.)
Gift of Mrs. Mellon Bruce in memory of her father, Andrew W. Mellon
1961.16.1

PAUL GAUGUIN
French, 1848–1903
Breton Girls Dancing, Pont-Aven, 1888 36
Oil on canvas, 73 x 92.7 cm (28 3/4 x 36 1/2 in.)
Collection of Mr. and Mrs. Paul Mellon
1983.1.19

FRANCISCO DE GOYA
Spanish, 1746–1828
María Teresa de Borbón y Vallabriga, later
Condesa de Chinchón, 1783 78
Oil on canvas, 134.5 x 117.5 cm (53 x 46 1/4 in.)
Ailsa Mellon Bruce Collection
1970.17.123

STURTEVANT J. HAMBLIN
American, active 1837/1856
Little Girl with Pet Rabbit, c. 1845 58
Oil on paper attached to panel, 30.7 x 24.5 cm (12 1/16 X 9 5/8 in.)
Gift of Edgar William and Bernice Chrysler Garbisch
1953.5.70

HANS HOLBEIN THE YOUNGER
German, 1497/98–1543
Edward VI as a Child, probably 1538 10
Oil on panel, 56.8 x 44 cm (22 3/8 x 17 3/8 in.)
Andrew W. Mellon Collection
1937.1.64

WINSLOW HOMER
American, 1836–1910
Breezing Up (A Fair Wind), 1873–76 42
Oil on canvas, 61.5 x 96.7 cm (24 3/16 x 38 1/16 in.)
Gift of the W. L. and May T. Mellon Foundation
1943.13.1

PIETER DE HOOCH
Dutch, 1629–84
The Bedroom, 1658/60 18
Oil on canvas, 51 x 60 cm (20 x 23 1/2 in.)
Widener Collection
1942.9.33

EASTMAN JOHNSON
American, 1824–1906
The Brown Family (detail), 1869 70
Oil on paper mounted on canvas, 59 x 72.4 cm (23 1/4 x 28 1/2 in.)
Gift of David Edward Finley and Margaret Eustis Finley
1978.72.1

SIR THOMAS LAWRENCE
British, 1769–1830
Lady Mary Templetown and Her Eldest Son, 1802 62
Oil on canvas, 215 x 149 cm (84 5/8 x 58 5/8 in.)
Andrew W. Mellon Collection
1937.1.96

GARI MELCHERS
American, 1860–1932
The Sisters, 1884/1900 82
Oil on canvas, 150.5 x 100.8 cm (59 1/4 x 39 5/8 in.)
Gift of Curt H. Reisinger
1957.4.2

CLAUDE MONET
French, 1840–1926
The Artist's Garden at Vétheuil, 1880 80
Oil on canvas, 151.5 x 121 cm (59 7/8 x 47 5/8 in.)
Ailsa Mellon Bruce Collection
1970.17.45

The Cradle — Camille with the Artist's Son Jean, 1867 40
Oil on canvas, 116.2 x 88.8 cm (45 3/4 x 34 in.)
Collection of Mr. and Mrs. Paul Mellon
1983.1.25

Woman with a Parasol — Madame Monet and Her Son, 1875 6
Oil on canvas, 100 x 81 cm (39 3/8 x 31 7/8 in.)
Collection of Mr. and Mrs. Paul Mellon
1983.1.29

BERTHE MORISOT
French, 1841–95
The Artist's Daughter with a Parakeet, 1890 8
Oil on canvas, 65.6 x 52.1 cm (25 3/4 x 20 1/2 in.)
Chester Dale Collection
1963.10.50

AMMI PHILLIPS
American, 1788–1865
The Strawberry Girl, c. 1830 30
Oil on canvas, 66.3 x 56.3 cm (26 1/8 x 22 1/8 in.)
Gift of Edgar William and Bernice Chrysler Garbisch
1953.5.59

PABLO PICASSO
Spanish, 1881–1973
Le Gourmet, 1901 20
Oil on canvas, 92.8 x 68.3 cm (36 1/2 x 26 7/8 in.)
Chester Dale Collection
1963.10.52

CAMILLE PISSARRO
French, 1830–1903
Peasant Girl with a Straw Hat, 1881
Oil on canvas, 73.4 x 59.6 cm (28 7/8 x 23 1/2 in.)
Ailsa Mellon Bruce Collection
1970.17.52

SIR HENRY RAEBURN
British, 1756–1823
The Binning Children, probably c. 1811
Oil on canvas, 128.8 x 102.7 cm (50 3/4 x 40 3/8 in.)
Given in memory of John Woodruff Simpson
1942.5.2

AUGUSTE RENOIR
French, 1841–1919
Girl with a Hoop, 1885
Oil on canvas, 125.7 x 76.6 cm (49 1/2 x 30 1/8 in.)
Chester Dale Collection
1963.10.58

A Girl with a Watering Can, 1876
Oil on canvas, 100.3 x 73.2 cm (39 1/2 x 28 3/4 in.)
Chester Dale Collection
1963.10.206

GEORGE ROMNEY
British, 1734–1802
Miss Juliana Willoughby, 1781–83
Oil on canvas, 92.1 x 71.5 cm (36 1/4 x 28 1/8 in.)
Andrew W. Mellon Collection
1937.1.104

JAN STEEN
Dutch, 1626–79
The Dancing Couple (detail), 1663
Oil on canvas, 102.5 x 142.5 cm (40 3/8 x 56 1/8 in.)
Widener Collection
1942.9.81

THOMAS SULLY
American, 1783–1872
The Leland Sisters, c. 1830
Oil on canvas, 41.2 x 50.7 cm (16 1/4 x 20 in.)
Gift of Mrs. Philip Connors
1973.4.1

JAMES JACQUES JOSEPH TISSOT
French, 1836–1902
Hide and Seek (detail), c. 1877 64
Oil on wood, 73.4 x 53.9 cm (28 7/8 x 21 1/4 in.)
Chester Dale Fund
1978.47.1

ELISABETH VIGÉE-LEBRUN
French, 1755–1842
The Marquise de Pezé and the Marquise de Rouget with Her Two
 Children, 1787 46
Oil on canvas, 123.4 x 155.9 cm (48 5/8 x 61 3/8 in.)
Gift of the Bay Foundation in memory of Josephine Bay Paul and
Ambassador Charles Ulrick Bay
1964.11.1

EDOUARD VUILLARD
French, 1868–1940
Child Wearing a Red Scarf, c. 1891 86
Oil on cardboard on wood, 29.2 x 17.5 cm (11 1/2 x 6 7/8 in.)
Ailsa Mellon Bruce Collection
1970.17.90

JOHANN ZOFFANY
British, 1733–1810
The Lavie Children, c. 1770 14
Oil on canvas, 102.5 x 127.6 cm (40 3/8 x 50 1/4 in.)
Paul Mellon Collection
1983.1.48

Index of Poets and Poems

Dorothy Aldis: "Hiding," reprinted with permission of G. P. Putnam's Sons from *All Together*, Copyright © 1925 by Dorothy Aldis; Copyright renewed © 1980 by Roy E. Porter.

Elizabeth Coatsworth: "Nosegay," reprinted with permission of Simon & Schuster Books for Young Readers from *Summer Green* by Elizabeth Coatsworth. Copyright © 1948 by Macmillan Publishing Company; Copyright renewed © 1976 by Elizabeth Coatsworth Beston.

Elizabeth Maddox Roberts: "Father's Story," from *Under the Tree* by Elizabeth Maddox Roberts. Copyright © 1922 by B. W. Huebsch, Inc., renewed © 1950 by Ivor S. Roberts. Copyright © 1930 by Viking Penguin, Inc., renewed © 1958 by Ivor S. Roberts. Reprinted with permission of Viking Penguin, a division of Penguin Books USA Inc.

Walter de la Mare: "Some One," reprinted with permission of The Literary Trustees of Walter de la Mare, and The Society of Authors as their representative.

Kim Nam-Jo: "My Baby Has No Name Yet," reprinted from *Contemporary Korean Poetry*, ed. & trans. by Ko Won, with permission of the University of Iowa Press. Copyright © 1970 by the University of Iowa Press.

Carl Sandburg: "Little Girl, Be Careful What You Say," from *The Complete Poems of Carl Sandburg*, Copyright © 1950 by Carl Sandburg and © renewed 1978 by Margaret Sandburg, Helga Sandburg Crile, and Janet Sandburg. Reprinted with permission of Harcourt Brace & Company.

Edna St. Vincent Millay: "Afternoon on a Hill," from *Collected Poems*, HarperCollins. Copyright © 1917, 1945 by Edna St. Vincent Millay.

Acknowledgments